IMAGES
of America

JOHNSBURG AND PISTAKEE BAY

The early settlers to the area were able to purchase tracts of land from the government. Their names can be seen on this map from the 1800s. Many of them farmed their land, while others developed local businesses. The Pistakee Bay area can be seen below the number seven on the map. It was here that Chicago residents came to hunt, fish, and enjoy the clean country air. (Courtesy of Sue Nell.)

On the cover: Like many area residents, Glen and his father, Louis "Bud" Hartmann, spend warm summer days in their canoe on the Fox River. Young Glen, wearing his sailor hat, enjoys paddling the canoe while his father sits patiently in the rear of the canoe. The new Johnsburg Bridge, pictured in the background, was dedicated in 1939. (Courtesy of Cheryl Twomey.)

IMAGES
of America

JOHNSBURG AND PISTAKEE BAY

Sandra Landen Machaj

ARCADIA
PUBLISHING

Copyright © 2008 by Sandra Landen Machaj
ISBN 978-0-7385-6158-5

Published by Arcadia Publishing
Charleston SC, Chicago IL, Portsmouth NH, San Francisco CA

Printed in the United States of America

Library of Congress Catalog Card Number: 2008925945

For all general information contact Arcadia Publishing at:
Telephone 843-853-2070
Fax 843-853-0044
E-mail sales@arcadiapublishing.com
For customer service and orders:
Toll-Free 1-888-313-2665

Visit us on the Internet at www.arcadiapublishing.com

To Blair: You have brought joy to our lives since the day of your birth. We are proud of your accomplishments. Continue to reach for your dreams for they are always achievable. You are always in our hearts.

CONTENTS

Acknowledgments		6
Introduction		7
1.	Settling Johnsburg: A New Community	9
2.	Nurturing the Community: The Community Club	35
3.	The Heart of Johnsburg: St. John the Baptist Church	49
4.	Education: The Johnsburg Way	59
5.	Sailing the Bay: The Pistakee Yacht Club	65
6.	At Play: Pistakee Bay	77

Acknowledgments

Embarking on a journey through time to record the history of Johnsburg and Pistakee Bay was not a solo excursion. I was accompanied throughout this trip by the many residents of the area who took the time to share their memories and the photographs of their ancestors with me. To all of them I am deeply appreciative.

This journey began with Pat Shafer, who encouraged me to write this book. In addition, she spent many hours helping me contact people and assisting me in researching the area. Thank you Pat for all your support and unending list of telephone numbers.

Next a special thank-you to Mike Clark, who has a wonderful collection of photographs and postcards of the Johnsburg-Pistakee area and who graciously allowed the use of them for this book. Mike as well as Harry May shared their knowledge of Johnsburg over many hours. Thank you also for reviewing some of my writing.

Thank you to Dr. Duane Andreas, Nancy Baker, Mary Jane Bartlow, Gail Carter, Marya Dixon, Dave Dominguez, Sally Lucke Elkes, Tom Fuchs, Walter Gehlaar, Chuck Geis, Tim Harrison, Wayne Hiller, Tom Huemann, Carol Janssen, Chris Kerwin, Sue Nell, Chuck Peterson, Jona Rice, Priscilla Rutter, Trudy Schuch, Peter and Jill Theis, Cheryl Twomey, and Dawn and Mark Wicks, for their contributions. To anyone I may have inadvertently omitted, please accept my apology and my thanks.

To Nancy Fike and the McHenry County Historical Society, thank you for your great collection and the use of it.

Lastly, thank you to Jeff Ruetsche, my editor at Arcadia Publishing, for his help.

Introduction

Johnsburg and Pistakee Bay are connected by proximity to each other and to the water. They developed in the same time period but as far different communities. Johnsburg was settled by hardworking German immigrants who farmed the land and built businesses to serve the people of the area. Pistakee Bay brought Chicagoans looking for a place to escape the summer heat of the city and to enjoy the recreational possibilities of the lake.

The first settlers to Johnsburg, arriving in 1841, were German Catholics who were looking for a place to raise their families and practice their religion without persecution. They settled in this area in northeastern McHenry County and cleared their land, provided shelter for their families, and built a church.

Their lives were family and church centered. Both religious and social activities were church affairs. They opened the first Catholic school in McHenry County, holding classes in the log building that was their church. As they outgrew their church, they built another and then a third building. The third church was in the traditional Gothic style. When it burned in 1900 the community immediately began rebuilding, larger and grander than before.

The school system was unlike any other in the area. A one-room community school was added in 1866. By 1901, due to the pressure of increased enrollment, a larger two-story building was built to house the Catholic school. It was built next to the one-room community school. The School Sisters of St. Francis were contracted to teach at both the Catholic and the one-room community schools. The sisters continued to teach in both the public and Catholic schools until the 1950s when a community member filed a lawsuit to prevent the sisters from continuing in the public school.

In 1922, the Community Club was formed and basically took charge of activities normally handled by government. It was instrumental in obtaining state funding for road pavement and building a new bridge. It provided food and financial assistance for those in need. It was actively involved in recreational activities in the village. Baseball, Johnsburg's favorite sport, was and continues to be supported by the club.

Sports activities were a community event. Whether it was a school game or one of the semiprofessional team, there was always a large crowd to cheer them on. Rivalries between Johnsburg and neighboring towns brought out the best efforts from both teams. The Chicago White Sox were enticed to come to Johnsburg to play an exhibition game. A local player, Chuck Hiller, became a major-league player and made baseball history as the first National League player to hit a grand slam home run in a World Series game.

Johnsburg volunteers formed the first rescue squad in McHenry County in 1952.

Although settled in 1841, Johnsburg did not become a village until 1991. Even then the method of incorporating was unique. Concerned that the growth of neighboring communities would stifle Johnsburg's ability to grow and retain its own individual personality, incorporation was unsuccessfully attempted. A section of Johnsburg known as Sunnyside was successful in incorporating, allowing Johnsburg to merge into the Village of Sunnyside. Shortly thereafter the village name was changed to Johnsburg.

Today Johnsburg is a unique community. While suburban sprawl begins to creep up Route 31, the majority of the village maintains a serene country image. A village sewer system is just becoming a reality. Private wells still provide water to residents. Johnsburg, while keeping one foot planted firmly in its past, moves on into today's world with the other one.

In the early 1800s, Pistakee Bay was an unsettled lake best known for its shallow, muddy bottom and a shoreline of tall grasses. It was a wonderful habitat for wildlife, especially ducks and birds. By the 1870s, visitors to McHenry County began to realize the potential recreational value of the area.

Visitors, mostly from Chicago, found their way to the bay. Many of them arrived by train at the McHenry station or later at the Pistakee station in Fox Lake. From there they would travel by excursion boats to the bay. They found the area to be a wonderful place to camp, hunt, and fish.

A picnic grove was established at Pitzen's Point in 1875. Men who originally came to hunt and fish returned with their families to camp on the shores. Steamboat rides along the river, often with a band playing on board, proceeded into Grass Lake to view the famous lotus beds.

As more visitors journeyed to the bay to escape the heat and grime of the city, accommodations were built. Some were small primitive fishing cabins while others were lavish resorts, which attracted the movers and shakers of Chicago business and political communities.

Noah Pike, a lumber dealer, is believed to have built the first cabin on Pistakee Bay in 1884. He is sometimes referred to as the "Father of Pistakee Bay." Other prominent businessmen followed with cabins or more lavish homes of their own.

By the 1890s many prominent Chicagoans made the bay their summer residence. A group led by Henry L. Hertz that was interested in sailing formed the Pistakee Yacht Club in 1897. Originally run from the pier of the Hertz house, the club purchased land from Mary P. Hertz and by 1900 built the clubhouse. The club continues in existence today at the same location, using the same building, which has been remodeled as needs changed.

With the growth of the yacht club, organized social activities became a reality. The weekend sailboat regattas brought other boaters into the bay. Picnics out on the lawn of the club would often follow the day's boating activities. Dances with big-name bands would be held, and when the yacht club closed the party would move to one of the large houses on the bay.

George Sayer, reported to be the wealthiest of all the wealthy Pistakee residents, built a palatial home of McHenry artificial stone that was named Rose Villa, in honor of his wife, Rose. The 32-room house included a ballroom on the third floor and eight fireplaces. In addition to his large estate on the bay, Sayer also owned five farms and an exotic animal park. After Sayer's death the house was sold to William (Billy) Skidmore, a known Chicago gambler with connections to the Chicago syndicate. Skidmore continued the tradition of Sayer by providing employment for many of the local residents on his farms and estate.

Chicago political figures were prominent on the bay. Sen. William Lorimore, a summer resident of the bay and a supporter of Chicago mayor "Big Bill" Thompson, lost his senate seat after being accused of buying votes in the 1910 election.

Many other highly connected politicians called Pistakee Bay their summer home. Their presence probably aided the development of the bay area by bringing roads and electricity to the area.

Today the bay area is a year-round community with a rich history. Many of the original homes are still present, and in some cases ownership by descendants of the original residents has been maintained.

Join this journey through time to visualize the past and present of Johnsburg and Pistakee Bay.

One

Settling Johnsburg
A New Community

In the 1800s, the Eiffel region of Germany was ruled by Prussia. Prussia, trying to recover from the effects of the Napoleonic Wars, taxed the area heavily. The land was in poor condition for farming, making it difficult for farmers to support their families and pay their taxes. These conditions forced many of the residents to search for a better life.

Nicholas Frett, Jacob Schmitt, and Nicholas Adams were three of these residents. They left the area and traveled to America with hopes of finding better conditions. They left their families in Chicago and began their search for a place to settle where they could farm and raise their children. On August 2, 1841, they arrived in the area that today is known as Johnsburg.

Impressed by the area located near the Fox River as it flows out of Pistakee Lake, Frett and Adams each purchased 160 acres of land and Schmitt purchased 60 acres at $2.50 per acre. Pleased with their new life, they wrote to friends and family in Germany and encouraged them to immigrate here. Some of them did, and Johnsburg began to grow.

The source of the name Johnsburg is not known for sure. It is thought that it may have been chosen in honor of Nicholas Frett's son Johann, who continued to farm the Frett land after the death of his father.

This building was constructed in 1857 and has been the site of many different businesses. In 1905, John C. Debrecht purchased the building from John P. Lay. Debrecht, who came from Chicago, opened a grocery store at this location. Salt could be purchased in 250-pound barrels. Salt was used in great quantity to preserve meat and to pickle vegetables. The next owner was Ben Schaefer, another Chicagoan, who opened a meat and grocery business. In 1951, Joe Hiller purchased the building and again opened a grocery store, which he named the Johnsburg Food Mart. Since 1981 various other businesses have made this building home. Local lore suggests that a brewery operated in the basement, possibly during Prohibition. (Courtesy of Michael Clark.)

Many buildings in Johnsburg changed usage over the years. This building located at 2220 Johnsburg Road was one that housed several unrelated businesses at different times. In 1897, it was the home of the Johnsburg post office. In 1907, a tavern opened here, which continued in business at this location until 1917. The next business to make this building home was a barbershop. (Courtesy of Michael Clark.)

This photograph bears little resemblance to the building pictured above, but it is the same building. Located on the corner of St. Johns and Johnsburg Road, it underwent a renovation and remodeling to become a family home in 1945. (Courtesy of Donna Swartzloff and Linda Koepke.)

Originally a creamery, this building was constructed in 1886. It was operated by E. Buchanan, who specialized in manufacturing cheese. Milk was brought by the local farmers in horse-driven wagons to the building. In 1902, Joseph Huemann purchased the building. Once the home of the Johnsburg Rescue Squad, it is currently the home of Pitzen's Auto Repair. (Courtesy of Michael Clark.)

Some of the buildings that are found on the main street of Johnsburg (Johnsburg Road) today were present in the early 1900s. They were the sites of the general store, grocery stores, and blacksmith shop that provided wares for the farm families. At the time of this photograph, horses were the mode of transportation. It would be a few years until automobiles took over the roads and until the 1930s before the roads would be paved. (Courtesy of Michael Clark.)

Castor Adams built this general store in 1915. He sold dry goods and groceries. He remained in business at this location until his death in 1931. Castor's son Arthur opened a grocery business here in 1933 but only remained until 1936, when he relocated to Chapel Hill Road. (Courtesy of Michael Clark.)

In the early 1900s, Chapel Hill Road was an unpaved narrow road. The narrow bridge over the Fox River identified here as the Wagon Bridge allowed farmers from the other side of the river to travel into town to purchase supplies. The bridge was replaced in 1938. (Courtesy of Michael Clark.)

Chapel Hill Golf Club was opened in 1898 as a nine-hole course. In the 1950s, land was purchased from the Schmitt family for the addition of nine more holes. The clubhouse was added at that time. The Schmitt Chapel, built in 1843, still stands on the grounds but is not owned by the golf club. (Courtesy of Michael Clark.)

Swimming in the Fox River was a popular pastime for local teenagers. Two people would start out in a rowboat at the Johnsburg Bridge. Then one would dive into the water and attempt to swim down to the McHenry Bridge while the other rowed along. Here Martha Miller prepares to dive into the river for her swim up to the bridge. (Courtesy of Diane Niess.)

Hettermann's Tavern was a local hangout that was popular with residents of Johnsburg and visitors. In 1933, Joseph and Helen Hettermann opened the restaurant and tavern on the corner of Johnsburg Road and Chapel Hill. Helen provided the home cooking while Joe tended bar. It was not unusual to see local residents stopping in for a beer after work. As work progressed on the road and the bridge replacement, there was a need for housing for some of the workers. The Hettermanns rented rooms to these workers since there were no hotels in Johnsburg. They maintained a good business for many years. (Courtesy of Michael Clark.)

In the late 1800s, Henry Hettermann operated this blacksmith shop. Area farmers would bring their horses in for replacement shoes as needed. The building was destroyed by a fire in 1916. Rather than rebuild the blacksmith shop, Joe and Henry Hettermann replaced it with a new building, which would service the new automobiles that were being driven into town. The new building was named Central Garage by the Hettermanns and was the home of an automobile repair shop. The Hettermanns also sold gasoline at this site. They remained at this location until 1929. Fred J. Smith purchased the property from the Hettermanns. He converted the building into a Standard Oil gasoline station. Smith also opened the first Chevrolet dealership in Johnsburg at this location while maintaining the Standard Oil station. The Chevrolet dealership remained a fixture in Johnsburg until 1977. (Courtesy of Michael Clark.)

Inside Smith's Central Garage, Art Klein stands next to a 1938 Chevrolet that has been lifted on a service rack. This rack was one of the first in the area. Fred Smith and Fred Smith Jr. are standing while Norbert Smith is changing a tire on William (Billy) Skidmore's Packard. Skidmore, a known Chicago gambler, was a Pistakee Bay summer resident. (Courtesy of Harry and LuAnn Smith.)

If one's automobile was not running, a telephone call to 200J would bring Fred J. Smith out to tow it in to the Central Garage to be repaired. In 1940, this tow truck could be seen on the streets of Johnsburg. Smith's dog Duke found the truck to be a comfortable place to rest when not in use. (Courtesy of Harry and LuAnn Smith.)

NELL'S BALLROOM, JOHNSBURG BRIDGE

On the bank of the Fox River, Frank and Agnes Nell opened a tavern and dance hall. In the back was a large grove that was a popular place for picnics. Nell's Ballroom was a popular place for both local residents and visitors from surrounding areas to spend their evenings. The ballroom brought in both local and big-name bands to provide music. The three bars provided plenty of liquid refreshment to the dancers. (Courtesy of Michael Clark.)

In the late 1940s, the Daley family opened a bowling alley in the building that formerly held the dance hall. The Tomasello brothers took over the business in the 1950s and added a pizza parlor to the bowling alley. By the 1960s it became the Johnsburg Bowl. (Courtesy of Michael Clark.)

This Sinclair gas station was located on Chapel Hill Road. The station has a far different look from gas stations of today. There was no self-service here. The gas would be pumped by station attendants. This station did not have any bays for automobile repair. Note the automobile parked in front. It was the most popular color of the time—black. (Courtesy of Michael Clark.)

These Quonset huts were originally used as a rug factory in the 1940s. Located on Chapel Hill Road, they are near the intersection with Johnsburg Road. They have also been the home of a coil factory, a public works building, a water company, and a studio for music instruction. (Courtesy of Harry May.)

This was the most unique house ever to be built in Johnsburg. Built by John Behmiller in the 1950s, the pagoda-style house was reminiscent of the homes found in Jamaica where Behmiller had lived. The house was reported to have had 11 waterfalls and an indoor swimming pool. Off the pool was a stone door, which led into a cavelike bar while a waterfall flowed over the top. The house was featured in *Playboy* magazine. (Courtesy of Michael Clark.)

In the early 20th century, Steven May and Dena Stilling enjoyed a ride in this horse-drawn wagon through downtown Johnsburg. The cart had wooden wheels, making it a bumpy ride through the ruts that formed when it rained on the unpaved dirt road. (Courtesy of Trudy Schuchs.)

John W. Freund, who ran a general store and the post office, organized the Johnsburg Band in 1879. The band's first public appearance occurred on July 4, 1879, when it played for an Independence Day picnic. Even on a warm summer day, the band members did not shed their suit jackets or top hats. (Courtesy of Michael Clark.)

Weddings were important events even back in the early 1900s. In 1901, Joseph J. Freund married Catherine Bugner in a formal ceremony at St. John's Church. Catherine's wedding dress was a long formal dress but was not the traditional white of today. Her veil was floor length with a flowered wreath as a headpiece. Often the wedding dress became the bride's Sunday dress for many years, with or without alterations. Joseph wears a large boutonniere while no flowers are pictured with the bride. By 1926 when their daughter Hilda married William May, styles had changed. Hilda wore a formal white bridal gown, with a large headpiece that covers most of her hair and a long trailing veil. She carries a huge bouquet of daisies while hydrangeas line the floor in front of her. Hilda's dress is in keeping with the styles of the Roaring Twenties. (Courtesy of Harry May.)

In the early 1900s, it was not unusual for siblings to marry other siblings and to hold the weddings on the same day. Pictured on the right are Michael Freund and Mary Freund, while Matthew Freund and Elizabeth Freund are pictured below. They shared a wedding day on January 20, 1904. Michael and Elizabeth were siblings, as were Matthew and Mary. Note the identical wedding dresses. Neither of the brides changed their surnames, as both families were members of one of the Freund families of the area. Marriage celebrations often included the entire community. (Courtesy of Trudy Schuchs.)

In the late 1800s and early 1900s, weddings were always large, lavish affairs. Often the entire village was invited. This photograph of the guests of the Joseph Hettermann and Helen Smith wedding is typical of the wedding celebrations of the time. Everyone dressed in high fashion, even the small children. In order to include everyone in this photograph, three of the guests posed on the porch roof. (Courtesy of Michael Clark.)

A large wedding required the use of many cooks. Shown here, from left to right, are 15 cooks: (first row) Mrs. Fred Meyer, Maria May Freund, Catherine Hay Freund, and unidentified; (second row) Mrs. Willis Freund, unidentified, Susie Meyer Justen, Mary Hergott Schaefer, Christine Young May, and Anna Thelen Kattner; (third row) Mrs. Bill Hay, Anna Britz May, Catherine Meyer Freund, Lizzie May Engels, and Christine May Freund. (Courtesy of Michael Clark.)

Winter in Johnsburg means snow. This photograph of Nell's Ballroom and the Freund farm takes on the winter glow. On the left is Nell's Ballroom. In the center is the home of Leo and Martha Freund. Leo was a painter and decorator. The house to the right was built by Leo for his assistant. (Courtesy of Diane Niess.)

Automobiles always attracted young boys. The Huemann boys enjoy posing on the fender and running board of this automobile. Fred and Elmer seem to have left their shoes somewhere and are enjoying a barefoot day. Pictured from left to right are Elmer, Fred, and Joseph Huemann. (Courtesy of Tom Huemann.)

The Miller farm was located on Johnsburg Road at the Fox River. Farmers often used dynamite to clear the fields of debris. John A. Miller was attempting to dynamite his field in 1937 when the explosion did not go off as planned and he was killed. (Courtesy of Linda Koepke and Donna Swartzloff.)

Many farmhouses were built in stages. A one-story cabin is first built to house the family. As the farm and the farmer's family and resources grow, a two-story addition is built connecting to the original house. Pictured here on the Joseph J. Freund farm are, from left to right, Anna Bugner, Hilda Freund May, Catherine Bugner Freund, and Joseph J. Freund. (Courtesy of Harry May.)

Small milk houses such as this one located on the Freund farm were found on most farms. Milk produced on the farm was stored in the milk house until it was used by the farm family or sold to one of the dairies. Butter and cheese were also made with the milk. Pictured are members of the Freund family. (Courtesy of Harry May.)

Corn was grown on many of the farms in the Johnsburg area. Harvesting and husking the corn required the work of many men. Large machinery such as this corn husker was used as farmers worked together to bring in the crops. Tony Schmitt, pictured on the far right with Joseph J. Freund next to him, works with John Smith to operate the corn husker. (Courtesy of Harry May.)

Prior to motorized tractors, crops were planted and harvested utilizing teams of horses. In this 1900, photograph a farm family pitches in to harvest the grain. For the children it was work and fun as they climbed on the piles of harvested crops. Without the horses to transport the crops, moving them for sale or storage would have been a very difficult task. (Courtesy of Harry and LuAnn Smith.)

From left to right, Leo, Ben, Fred, John, and Lena Smith pose with the family dogs in the backyard of the family's homestead in the early 1900s. Fred Smith spends time practicing his baseball stance and swing. The huge pile of lumber would become the source of heat for the family home during the cold winter months. (Courtesy of Harry and LuAnn Smith.)

Wood for fires was an important commodity for farmhouses. These young women spend the day helping to cut wood for later use. Agatha Schmitt Thelen (left) and Eleanora Smith Altoff cut the logs into usable pieces with a crosscut saw while Clara Smith stands by with the ax ready to split the logs into firewood. (Courtesy of Harry and LuAnn Smith.)

Smith's Grocery Store was as close to a modern-day supermarket as could be. Canned goods, staples, and fresh vegetables were available. Smith had a large butcher shop to provide fresh meat to his customers. (Courtesy of Dori Smith Tonyan.)

Smith's Grocery Store had well-stocked shelves and prices that by today's standards were extremely inexpensive. Grapefruits were priced at three for 23¢, while a loaf of bread could be purchased for 29¢. Smith also would deliver groceries to his customers. (Courtesy of Dori Smith Tonyan.)

In the early 1900s, Joseph J. Freund farmed the area that is now known as the housing subdivision Jak-Ana Heights. Pictured standing in the doorway of his barn is Freund as he tends to his cows. Milk was produced by local farmers not only for their own use but also to be sold to the major dairies and then shipped to Chicago. (Courtesy of Harry May.)

The 170-acre farm in this aerial view was owned and worked by Jacob Justin. As was often the case, the neighboring farms were owned by other family members. In this case, it was Ben Justin. Having families nearby allowed the farmers to assist each other in harvesting crops or butchering livestock where more hands were needed. (Courtesy of Trudy Schuchs.)

This farm was located on Bay Road. It was originally one of several farms owned by William Skidmore. Skidmore was a summer resident of Pistakee Bay who was well known as a gambler from Chicago. The Skidmore farms provided employment for many of the local residents during the Depression years. The farm was later purchased by Louis "Bud" and Ethel Hartmann. (Courtesy of Cheryl Twomey.)

Before Johnsburg was incorporated and issued its own vehicle stickers, the rescue squad sold voluntary vehicle stickers as a way to raise money to support the squad. The stickers, as shown here, were in the shape of the state of Illinois and each year were presented in different colors. (Courtesy of the Johnsburg Rescue Squad.)

Not only did the members of the rescue squad donate their time to respond to emergencies, they also spent their free time building the new home for the rescue vehicles. From pouring cement to building walls, volunteers provided the necessary labor. Supplies were donated by members of the squad and local businessmen. This building with an addition now serves as fire station No. 2. (Courtesy of the Johnsburg Rescue Squad.)

The Johnsburg Rescue Squad was the first rescue squad in McHenry County and one of the first established in the state of Illinois. In 1952, a group of 12 men began to solicit donations to purchase needed equipment to form the squad. Original rescue squad members were Clem Freund, Gerald Hettermann, Fred Huemann, Kenneth Hamsher, Lloyd Oeffling, Richard Marshall, Albert Adams, John Stone, Bill Schmitt, and Harry Freund. (Courtesy of Michael Clark.)

By 1953 the squad was officially organized. Pictured are members of the rescue squad. From left to right are (first row) Dick Huemann, Tom Fowler, Chuck Violet, Harry May, Dick Seaborn, and Les Klotz; (second row) Ed Hettermann, Grace Bentz, Chuck Majercik, John Olsen, Bill Swartzloff, Don Bentz, Wayne Hiller, Alger Oeffling, and Harry Weber. (Courtesy of the Johnsburg Rescue Squad.)

33

In 1954, Johnsburg became the location of fire station No. 2 of the McHenry Fire Protection District. The old creamery became the firehouse. This 1959 picture was taken at the station with the original firemen standing in front of the building and trucks. Pictured from left to right are Jerry Hettermann, Norbert Smith, Fred Huemann, Joe Hiller, Harry Freund, Harry Smith, Albert Adams, Lloyd Freund, William Haig, Joel Adams, and Chief Otto Adams. (Courtesy of Harry and LuAnn Smith.)

In 1980, a committee of Johnsburg residents began working to allow Johnsburg to develop its own library. While there was community support for a library, there was also a faction that was opposed. The referendum was placed on the ballot three different times before it passed. In 1984, the first library opened in rented space. In 1996, a new library was built. (Courtesy of the Johnsburg Public Library.)

Two

Nurturing the Community
The Community Club

The Community Club was formed in 1922 as a civic organization that would help with the needs of the community and its residents. The club raised funds by holding social activities. Dances were often held at Nell's Ballroom or the St. John's Church hall. In 1953, the Community Club built its own hall and many events were held there. Music was provided by live bands such as the Fox River Skylarks or Vycital's Orchestra.

Community service was the club's main interest. During the hard times of the Depression, the club distributed food baskets worth $7.50 to those in need, an amount that seems negligible now but at the time was able to purchase a large amount of groceries. Its next major project was obtaining a paved road through the town. This was completed in 1932. It was also instrumental in obtaining a polling place in Johnsburg in 1937.

Replacement of the wooden bridge that spanned the Fox River became a major project. In 1938, funds of $150,000 were approved by Springfield. A bridge 450 feet long across the river was constructed.

Completion of the bridge called for a celebration, and the people of Johnsburg were always ready to celebrate. A parade originating at St. John's Church consisting of local schoolchildren, a band, Fr. A. J. Neidert, and community and state officials marched to the bridge.

In 1940, the club, led by Joe, Henry, and Ray Hettermann, Peter Smith, William Thiel, and Joe G. Huemann, sponsored the placement of a flagpole on the St. John's hill. The flag was raised for the first time at this location in August 1940.

During World War II, the club sent small stipends to each of the Johnsburg servicemen as a way of showing the community's support.

By 1953 the club had built its own community hall, which opened with much fanfare. The club has also always supported baseball in the community. It took responsibility for management of the baseball fields and has financially supported teams.

The club's most difficult and important accomplishment was spearheading the drive to incorporate the village. After two attempts to incorporate, it led the drive to annex into Sunnyside and to return the community name to Johnsburg.

The Community Club purchased Memorial Park in July 1952. In order to construct the building that would be named Memorial Hall, there was a need to raise funds. Bonds totaling $20,000 were issued and sold. The bond issue was a sellout as members purchased them as soon as they were available. With the selling of the bonds, ground was broken in 1952 for a large meeting hall with facilities that would allow the club to hold many activities from dinners to dances in the building. Outside stands a memorial to all the veterans who have and will serve in the armed forces.

36

After successfully completing a project to obtain a cement highway through Johnsburg, the Community Club turned its efforts to convincing the state to fund a new bridge over the Fox River. In March 1938, Johnsburg was notified by Springfield that $150,000 had been appropriated to replace the old bridge. The new bridge was built just south of the old one. Made of iron and cement, the new bridge would be 450 feet long. (Courtesy of Diane Neiss.)

As work progressed on the bridge, citizens began to plan for the official opening and dedication. Club members collected funds and began to formulate activities that would be part of this important day in Johnsburg's history. Many elected state officials and nearby mayors came to speak. Fr. A. J. Neidert blessed the new structure, the band played the "Star Spangled Banner," and on June 18, 1939, the new bridge was officially opened. Joseph T. Freund, township road commissioner, marched proudly in the parade. (Courtesy of Harry May.)

During World War II, Johnsburg honored servicemen participating in the war by erecting a memorial board with the names of those serving their country. The board was mounted near St. John's Church. While the sign was maintained throughout the war, it was removed at its conclusion. (Courtesy of Harry and LuAnn Smith.)

During World War II, the Community Club supported the servicemen of the community by providing small stipends to those serving their country. To further show community support for the war effort, on May 2, 1944, the club sponsored a Mother's Night. Over 250 people attended. (Courtesy of Michael Clark.)

The Saufen und Spiel is a celebration held each year on the second Sunday in September. Led by a parade, the festival brings out the community to enjoy food, dance, and of course, beer. The profits from the festival support the Community Club. (Courtesy of Michael Clark.)

The Saufen und Spiel is a time of food, beer, and dancing. Local square dancers take to the street where they do-si-do around their square, their full skirts swooshing in the air and boots clicking on the sidewalks. Square dancing has long been popular in Johnsburg. Many square-dance clubs would attend dances at local ballrooms such as Nell's Ballroom. (Courtesy of Michael Clark.)

Like most of the land of the area, what was to become the village of Sunnyside was farmland. This farm was part of the original land deeded to Nicholas Frett by the United States government prior to 1844. In 1914, it became known as Sunnyside Farm. The May family, like many other Johnsburg residents, ran a successful family farm here for many years. In 1940, Alfred J. May planned a subdivision of single-family homes on the land. He began developing the land, calling the subdivision Sunnyside Farm. Sunnyside Farm along with other adjoining subdivisions incorporated on April 9, 1956, as the Village of Sunnyside. Leonard Guge was the first president of the village. (Courtesy of Arlette Cable.)

In 1989, the Community Club created a committee to study the future of Johnsburg. It attempted incorporation on two occasions, but these attempts failed. Looking for a way to preserve Johnsburg's identity, the committee approached the Village of Sunnyside about annexation into their village. A referendum in 1991 successfully approved the annexation. The name of the combined village reverted to Johnsburg in 1992. Early supporters of the annexation agreement worked hard to encourage neighbors to support the movement. Pictured supporters are, from left to right, (first row) Linda Sandell, Bill Sandell, Jim ?, Cathy Mullen, Fred Diedrich, Harry May, and Andy Eichorn; (second row) Dave Dominguez, John Huemann, Tom Huemann, Al Jordan, Chuck Majercik, Scott Dixon, Mike Clark, and Wally Stephens. (Courtesy of Harry May and Michael Clark.)

The Johnsburg community displayed its pride in America by erecting a flagpole at Memorial Park that was 85 feet tall. The local band played the national anthem with community members joining in to sing while the flag was raised for the first time. Pictured from left to right are unidentified, Kenneth Hamsher, James Hettermann, Fr. Joseph Blitch, and Fred J. Smith, president of the Community Club. (Courtesy of Harry May.)

The year 1991, the year of incorporation and the 150th anniversary of the settling of Johnsburg, brought visitors Peter and Maria May from Hertin, Germany. The Mays, descendants of the same family that settled the area, participated in the many activities commemorating the event. They are shown here riding in the parade. (Courtesy of Michael Clark.)

After the incorporation of the Community Club as a not-for-profit organization in July 1951, the club purchased the Johnsburg Memorial Park. The park for many years had been the center of community sports activities. The park underwent a complete renewal, with help from donations from members and other residents, including the replacement of the backstop.

The picnic area at Memorial Park has been home to many festivities over the years. Celebrations such as the village incorporation and the yearly Saufen und Spiel are held here. It is also a good place to picnic before or after a baseball game.

Baseball was always the most popular sport in Johnsburg. Pictured is the team sponsored by Hettermann Restaurant and Bar. From left to right are (first row) Wayner Hiller, Hank Hiller, Ed Hettermann, and John Meyers; (second row) Ted Beskow, Bud Miller, Jerry Wakitsch, Bill Haag, Paul Bruhn, John Huff, and Leon Schmitt; (third row) Dick Hiller, Carl Neiss, Rich Marsh, Dick Frederick, Bill Kreutzer, Si Meyers, Lloyd Freund, Jim Freund, and Tom Oeffling. (Courtesy of Wayne Hiller.)

30th Annual Hit & Run BASEBALL BANQUET

January 16, 2006

Johnsburg Oldtimers Club

Each year the Johnsburg Old Timers Club sponsors a fund-raising effort to provide college scholarships for promising baseball athletes. The annual dinner has always attracted major sports figures. Vince Lloyd acted as master of ceremonies for the first 15 years and then was replaced by Wayne Messmer. Scholarship athletes must have played on a varsity baseball team during their high school years. (Courtesy of Wayne Hiller.)

The Johnsburg Tigers relax after a game. This photograph of the team was taken around 1940. The team members are, from left to right, Stan Freund, Norb Smith, Al Freund, Walter M. Smith, William Kruetzer, William "Bud" Myer, Ralph Schaefer, Ted Pitzen, and LeRoy "Bud" Miller. (Courtesy of Harry and LuAnn Smith.)

Lay's Tavern was a popular place for baseball fans to gather after the game in the 1930s and 1940s. Located near the baseball field in Memorial Park, it was a short walk. Fans and players would gather to celebrate wins or commiserate after losses. (Courtesy of Wayne Hiller.)

Chuck Hiller, a member of the 1952 championship softball team, went on to play in the major leagues. As a member of the 1962 New York Giants, he made history by becoming the first National League player to hit a grand slam home run in a World Series game. In the fourth game of the series, this home run allowed the Giants to beat the New York Yankees 7 to 3. In honor of Hiller, Johnsburg declared October 28, 1962, as Chuck Hiller Day. A community parade marched through Jak-Ana Heights to the bridge and then to the community center hall. At the hall a plaque was presented to Hiller. Hiller is shown here in his college baseball uniform. (Left, courtesy of the McHenry County Historical Society; below, courtesy of Wayne Hiller.)

Chuck Hiller Day

SUNDAY, OCT. 28, 1962

Chuck Hiller

Community Club Grounds, Johnsburg

12:30 P.M. — Parade from Jak-Ana Heights to Johnsburg bridge, concluding at Community Club Hall.

Reviewing Stand at Community Club Hall.

Presentation of Plaque

Parade will feature several well known bands, drum and bugle corps and baton units.

BASEBALL
Johnsburg Ball Park
CHICAGO
WHITE SOX
vs. Johnsburg
Wednesday, Oct. 2
Admission
$1.00

A good baseball game always brought out Johnsburg residents. In October 1929, 250 spectators assembled at the Johnsburg ballpark to watch as the Johnsburg baseball team, which was the current McHenry County champion, played the major-league Chicago White Sox. Unfortunately, the hometown fans were disappointed as Johnsburg was shut out 13-0. (Courtesy of Michael Clark.)

The Johnsburg baseball teams were always active and usually very strong teams. This photograph of the team was taken in the early 1930s. Pictured second from right in the first row is John A. Miller. Miller was killed in 1937 from a faulty dynamite explosion. (Courtesy of Donna Swartzloff and Linda Koepke.)

In July 1952, the Johnsburg Tigers participated in the Illinois State Semi-Pro Championship. Playing in Elgin, against the Elgin team, the Tigers won the game 2-1, becoming the state champions. The team that was fielded consisted of Chuck Hiller (third base), Howard Katz (first base), George Jackson (catcher), Howard Freund (second base), Art Jackson (center field), Bob Tipps (left field), Dick Hiller (right field), Norb Britz (shortstop), and Joe Jackson (pitcher). All of Johnsburg was so proud of the accomplishment of their team that they organized a parade and a party at the Community Club. Over 75 automobiles and floats participated in the parade, which toured much of the county. (Courtesy of Harry May.)

Three

The Heart of Johnsburg
St. John the Baptist Church

The parish of St. John the Baptist is almost as old as Johnsburg itself. Founded by the original settlers in 1841, the parish became the center of community activity. The first church was built by 1842, a simple log cabin that was outgrown by 1850. It was replaced with a larger wooden structure.

As the parish grew, many of the members recalled the beautiful Gothic churches in Germany and longed to build a similar one here. And in 1867 they began their dream church. Work began on the brick building, located on the hill in Johnsburg where it would tower over the community. For 13 years, community members worked to complete the edifice. For 20 years, parishioners enjoyed their beautiful church until February 18, 1900, when a fire broke out during Sunday mass. The fire destroyed the church, but fortunately there were no fatalities.

The spirit of the parish did not die with the loss of the church. Under the leadership of the Reverend Henry Mehring, pastor of St. John's parish from 1884 to 1908, building a new church became a priority. The new church, built in north German Gothic style, was larger and more elegantly appointed.

Over the years maintenance and repair of such a large structure was extremely expensive. But the parishioners of Johnsburg always found ways to raise money for the church. Some of them were quite unique. One, a house built by parish members to raise funds for the renovation, was dubbed the Personality House. At its completion it was raffled off and all funds were used to restore the church to its former glory. On another occasion, a private lottery club, called the Winner's Circle, was formed where parishioners purchased a membership for $1,000 and annual dues of $150. Each month a monetary stipend was raffled off.

The cemetery, which is located next to the church, is a historical record of the village of Johnsburg. For here the remains of most of the early settlers are interred.

Today the Church of St. John the Baptist still stands on the hill, overlooking the village of Johnsburg.

By 1867, the frame church that had been in use was no longer large enough to meet the needs of the parishioners. This traditionally styled Gothic church, similar to those in Europe, was begun. The church was not completed until 1880. This structure, which measured 50 by 133 feet, was erected at a cost of $45,000. It served the parish until 1900. (Courtesy of Michael Clark.)

While attending mass on February 18, 1900, parishioners experienced a life-threatening event. During the sermon smoke began to swirl around the ceiling. This smoke was the beginning of a major fire that completely destroyed St. John's Church. Fortunately, all those attending mass escaped without serious injury and no deaths occurred. (Courtesy of Michael Clark.)

Work on the present St. John's Church was begun in 1900, shortly after the previous church burned. This building, like the previous one, was built in Gothic style but on a much more elaborate scale. The steeple reaches a height of 159 feet and can be seen from a distance when approaching Johnsburg. (Courtesy of Michael Clark.)

With work progressing quickly on the rebuilding of the church, the parish prepared for the laying of the cornerstone. For the people of Johnsburg, it was a time to celebrate. Neighboring clerics and the bishop of the Rockford Diocese joined in the blessing of the building. Local schoolchildren marched in procession. (Courtesy of Joe Huemann.)

The interior of the church is as elaborate as the exterior. Stained-glass windows were placed along its entire length depicting scenes from the life of Christ. A life-size crucifixion scene towers above the delicately carved main altar. Two side altars, one dedicated to Mary and the other to Joseph, flank the main altar. These appear as smaller versions of the main altar. Hand-painted murals were brought from Germany to adorn the walls. Many life-size statues of saints, including the four evangelists, Matthew, Mark, Luke, and John, are placed high along the walls looking down on the praying parishioners. The interior of the church is in the form of a cross, with a length of approximately 150 feet. The width of the church varies from 65 feet at its widest to 45 feet. The dome towers above the center of the church at 45 feet high. (Courtesy of Michael Clark.)

By 1974 St. John's Church was in need of major renovations and repair. The parish council developed a unique way to raise the necessary funds. The St. John's Personality House was built and furnished by parishioners who volunteered their time, skills, and materials. Some 25,000 raffle tickets for the ranch-style home were sold for $10 each, raising $225,000 for the renovation. (Courtesy of Michael Clark.)

ST. JOHN'S 1975 PERSONALITY HOUSE

For Donation Ticket Information or Tickets
Each $10.00 Donation Will Receive One Ticket

Write To:

ST. JOHN'S PERSONALITY HOUSE COMMITTEE
4010 N. Blitsch Place, McHenry, Ill. 60050

Make Out Donation Checks or Money Orders To
"ST. JOHN THE BAPTIST RESTORATION FUND"

Kindly Give Your Full Name and Address and Phone Number
So Your Ticket Can Be Forwarded to You Promptly.

First communion day was an important day in the spiritual life of Catholic children. The class of communicants poses on the church altar. The girls are wearing white dresses with veils while the boys are dressed in white pants and dark blazers, as was the custom of the time. This is the class of 1953. (Courtesy of Harry May.)

This grotto, a replica of the shrine at Lourdes, France, where the Blessed Virgin appeared to a peasant girl named Bernadette in 1858, was placed in the cemetery in 1920. The grotto was built in Ohio of petrified stone and was erected in memory of Rev. H. Mehring. His grave can be reached by following a path from the grotto. It was dedicated in May 1921. (Courtesy of Duane Andreas.)

In memory of Our Lady of Perpetual Help, Rev. Anthony Vollman, pastor from 1930 until his death in 1938, built the Via Dolorosa in the churchyard. Visitors from throughout the country came on pilgrimages to pray in this impressive spot. In the back of the cemetery, the small chapel stood overlooking Lake Genesareth. (Courtesy of Michael Clark.)

A small replica of the first St. John the Baptist Catholic Church was built to commemorate the 150th anniversary of the parish. Carrying it in the parade are Joseph Hiller, center, with Betty Lou Hiller on the left and Geri Hiller. (Courtesy of Michael Clark.)

Nestled against the side of the church, St. John's Cemetery has been part of the parish since the beginning. A walk through the cemetery is a walk through time. Early settlers to recently deceased members of the community have made this their final resting place. Seated outside the cemetery are Estelle Hiller Klapperich (left) and Joan May Buss. (Courtesy of Harry May.)

This aerial view of the completed St. John's Church was taken prior to 1920. The cemetery can be seen as it was before the addition of the grotto and the lake. On the right side of the photograph are the two school buildings nestled together. The school burned on February 19, 1945. (Courtesy of the McHenry County Historical Society.)

While on the journey from Germany, the ship that carried Frederich Schmitt encountered a severe storm. Fearing for his life, Schmitt promised that if he survived the voyage he would build a chapel. He fulfilled his promise in 1843 when he built a small log chapel on what today is Chapel Hill Road. In 1853, the building was covered with brick. It still stands on the grounds of Chapel Hill Country Club.

Marie Nett Miller and her husband, Peter, were raising their children John, Anna Marie, Marie, Catharine, Justin, Anna, and Matthew on their farm. Unexpectedly Peter died, leaving the burden of raising the children to Marie. In 1863, Marie promised that if God would allow her to raise her children in the "fear and love of God" she would build a chapel. (Courtesy of Trudy Schuch.)

Ten years after she made her promise, Marie's oldest son purchased the farm, and knowing of her desire to build a chapel, granted her the land to do so. The small white chapel was built in 1878. The chapel stands on the corner of Ringwood Road and Wilmot Road. The site received a plaque from the McHenry County Historical Society in 1998, marking it as a historical landmark.

The first Sunday in October brings descendants of Maria Nett Miller to the chapel that she built for a family commemorative mass. Members of the Miller family attend in such large numbers that there is not room in the chapel to seat them. Some stand in the field outside the chapel door. (Courtesy of Trudy Schuch.)

For many Catholic families, having a son or daughter become a priest or nun is the highest honor that can be given to them. Over the years, St. John's parish has been very proud of the number of sons and daughters of parishioners who have chosen religious life. At least 12 men and over 20 women have made this choice. Pictured are Michael and Ann Schaefer, who had two daughters chose religious life. (Courtesy of Sue Nell.)

Four

EDUCATION
THE JOHNSBURG WAY

What could be unique about a small school district in a little country town? If that district is Johnsburg, what is there that is not unique? The school system that developed was not the simple public school and separate Catholic school but an interwoven system that at times functioned as one school system. Johnsburg developed a school system that was controversial, forward-looking, and very positive for the students.

What began as a Catholic school in 1843, holding classes in the original St. John's Catholic Church, evolved into a separate one-room schoolhouse in 1886. It was known as the community or district school. For Johnsburg the village and the church were often felt to be one and the same, for all the residents of the area were German Catholics.

With the enrollment continuing to increase, a second school was built adjacent to the district school in 1901. The School Sisters of St. Francis from Milwaukee were hired to teach in both buildings, a situation that did not seem unusual to the residents of Johnsburg.

After a fire in 1945 destroyed the school, temporary accommodations were made until a new school could be built. A public school was built. Of course, the sisters were hired to teach the students.

In 1953, a parent not of the Catholic faith sued the school district for running the public school as a Catholic institution. The school board acted quickly to remove the nuns from the school, resulting in the suit being dismissed. The building of the new St. John's School seemed to separate the systems.

By 1968 Johnsburg was known for innovative educational developments; modern methods of education and gifted programs were introduced. Extracurricular clubs were encouraged. The district was the only one in the area that allowed dual enrollment in junior high. Dual enrollment allowed St. John Junior High students to take advantage of the science laboratories, foreign language, advanced mathematics curriculum, and art curriculum available at the public school. In addition, closed circuit instruction was shared by the public elementary school and St. John's for art and foreign language.

Formation of a unit district allowed students to remain in Johnsburg District 12 from kindergarten through high school.

In 1866, a one-room school building, shown on the right, was built. It became known as the district or community school. By 1901, more classroom space was required for the growing community. A second building, shown on the left, was built right next to the existing school. The larger building was named St. Joseph's School. Classrooms were located on the first floor while the second floor was used as a meeting hall for the church. With the new building in place, the School Sisters of St. Francis were contracted to teach in both schools. The smaller building became the seventh- and eighth-grade classrooms. In February 1945, a fire destroyed the building. Classes were held in Hettermanns' garage with some classes only attending half days. The seventh and eighth grades were able to continue in the community school building. (Courtesy of Duane Andreas.)

These 28 children were enrolled in the Catholic school in 1914. The School Sisters of St. Francis had replaced the lay teachers who first taught in the school. In honor of the sisters' motherhouse in Milwaukee, the school was named St. Joseph's School. It was later changed to St. John's School. (Courtesy of Harry May.)

By 1958 the graduating class of St. John's School was larger than the entire school enrollment had been in 1914. The class poses in front of the altar with Fr. Joseph Blitch. Dress styles of the year included full skirts. As women were required to cover their heads when in church, the girls all have flower crowns. The boys, who can be barely seen in the background, are probably wearing their first suits. (Courtesy of Harry May.)

At first glance this appears to be the yearly classroom photograph of a class in a Catholic school. Despite the Catholic sister standing in the rear of the classroom, it is actually the 1952 photograph of second and third grade in the Johnsburg Public School. From 1901 until the 1950s, Catholic sisters were hired to teach in the public school. (Courtesy of Harry May.)

In 1950, a new school was completed. This eight-room building was built as a public school. In keeping with the Johnsburg tradition, six nuns were hired to teach here. This arrangement continued until 1953, when a Johnsburg resident filed a complaint against the Johnsburg School District alleging that the public school was being operated as a parochial school. The school board at its regular meeting discontinued the policy of hiring nuns, resulting in a dismissal of the suit. This school is now named after James C. Bush, a former superintendent. (Courtesy of Duane Andreas.)

Because of the change in the public school, in 1953 St. John's parish built a new parochial school. The nuns taught in the Catholic school while lay teachers were hired to teach in the new public school. The two systems were thus truly separated. Then in 1967, the Johnsburg schools again became unique. Under the direction of superintendent Dr. Duane Andreas, the district embraced an innovative program known as dual enrollment. Under this program, Catholic school junior high students could attend the new public school junior high half days to study science, mathematics, Spanish, and physical education. St. John's was the first Catholic school in McHenry County to participate in this type of program. The St. John's varsity basketball team is pictured with trophies after a successful 1956–1957 season. The team, although it represents St. John's School, is actually a combination of players from St. John's and the Johnsburg Public School. (Courtesy of Harry May.)

By 1972 Johnsburg, wishing to control the teaching of its children through high school rather than sending them to McHenry for these years, began to discuss the idea of forming a unit district. A unit district would allow Johnsburg students to attend school from kindergarten through high school in Johnsburg. In August 1975, the Johnsburg Community Unit School District was formed. A bond issue to build a high school was passed. The new high school opened in 1978. Pictured below is the first district unit school board. From left to right are (first row) Barb Stanell, president Charlie Book, and secretary Bobbie Hart; (second row) John Heidler, Jerry Sobiesh, Jim Preston, and Tom Cahill. (Courtesy of Duane Andreas.)

Five

SAILING THE BAY
THE PISTAKEE YACHT CLUB

In the 1890s, summer residents of Pistakee Bay used the lake for both transportation and pleasure. While some favored powerboats, a group of residents headed by Henry L. Hertz preferred using the power of the wind to sail across the lake.

Hertz was known for his fleet of five sailboats. He shared his love of sailing with like-minded friends and in 1897 began to interest them in the formation of a yacht club. By December 1897, Hertz, with fellow sailors Phillip Jaeger Jr., Edwin Blomgren, Alexander Beck, William M. Gunton, Phillip Knopf, Ernest Heidenbergh, and Nicholas Morris, had incorporated the Pistakee Yacht Club as a not-for-profit corporation in Illinois.

Originally the Hertz home, located near the site of the present yacht club, was the center of yachting activities. In 1899, funds were raised to build a clubhouse on property owned by Mary P. Hertz, wife of Henry.

The club quickly became the center for social activities. Dances, men's smokers, minstrel shows, bazaars, card parties, and Venetian Nights were instrumental in providing entertainment for members and raising money to support needed improvements to the property.

In 1910, a Pistakee County Fair was held on the club grounds to raise money to pay off the mortgage on the land, which had been purchased from the Hertz family. The fair included dice games, slot machines, animal exhibitions, and the sale of imported items. The featured attraction was wrestling matches by Clarence "Pete" Peterson, then 20 years of age. At this fair, Samuel Insull provided bulbs, wiring, and current—bringing electric lights to the bay for the first time.

The weekend sailboat races emanating from the club's piers brought many sailors to the area. The 1960 addition of a Blue Chip Regatta, first conceived by John Loose, provided a race that would bring, by invitation, the best of the year's class C crafts to challenge each other.

The Pistakee Yacht Club was a charter member of the Inland Lake Yachting Association and has had influence over yacht design and racing rules. Today the yacht club continues to thrive and is host to many sailing and social events.

For over 100 years this building has stood as the home of the Pistakee Bay Yacht Club. Originally built in 1899, it has undergone many renovations and additions for it to become the building seen today. The clubhouse was built after raising $2,300 in a subscription drive. The building served as a dance pavilion in the summer and in the winter as a storage area for members' boats. In 1902, a boathouse was constructed at a cost of $1,500 but was demolished in 1914 to provide a lawn area. On November 21, 1910, the mortgage on the land was retired. During World War I, interest in the club dropped, causing the clubhouse to fall into a state of disrepair. Extensive renovations occurred in the 1920s and again in the mid-1930s. The photograph at left is the clubhouse as it looked in 1905. The one below reflects its current appearance. (Left, courtesy of Chuck Peterson; below, courtesy of Richard Higgons.)

Two types of racing sailboats called scows are pictured here. In the forefront is the larger, two-sailed scow, which was 38 feet long. Behind it the smaller 20-foot scow with only one sail is pictured. In the early 1900s, both types of scows were present racing on the lake. Today only the 20-foot boats are used. (Courtesy of Chuck Peterson.)

On race days, the pier at the Pistakee Yacht Club becomes the hub of activity as sailors prepare their scows. With sails unfurled they line the dock as other members of the club stand on the pier to watch the day's event. All races started from the club's pier. (Courtesy of Chuck Peterson.)

The Pistakee Yacht Club was the gathering place for many summer social events. Everything from afternoon tea, picnics on the lawn, and evening dances began at the yacht club. This group picture was taken at a yacht club gathering in the early 1900s. (Courtesy of Sally Lucke Elkes.)

Clarence (Pete) Peterson with son Chuck Peterson admires a trophy they earned in the late 1930s. The father-son duo often sailed and competed together. Clarence was the son of Franz Peterson, one of the early members of the yacht club. Clarence was a wrestler who was the Swedish heavyweight champion. Chuck Peterson is a current member of the yacht club and an active sailor. (Courtesy of Chuck Peterson.)

The large sterling silver punch bowl with its ebony base, pictured in the center, was first won by Henry L. Hertz in a regatta held on Lake Michigan on July 4, 1900. In 1906, Hertz deeded the trophy to the yacht club to be awarded as a perpetual trophy for sloop competition on July 4. The trophy, now named the Henry L. Hertz Trophy, continues to be awarded each July 4 to the winner of the class C yacht race. If there is not enough wind, the race is not held and therefore no new name is inscribed on the trophy The Haas trophy pictured on the right was donated by J. Robert Haas and McKenzie H. Riddell in 1927 to honor their grandfather Commodore Joseph F. Haas. It is awarded to the winner of a special race held on Labor Day. Pictured with the trophies is Clarence Peterson. (Courtesy of Chuck Peterson.)

Judges for the many races and regattas held by the Pistakee Yacht Club viewed the race from a barge out in the bay. From their vantage point they could observe the entire race, keeping track that each yacht stayed on the prescribed racecourse. Any infractions would be noted by the judges. (Courtesy of Chuck Peterson.)

In the early 1900s, this boathouse could be seen along the shore of Pistakee Bay. Having a boathouse on the shore was the envy of other residents of the bay. The boathouses protected the boats during times of inclement weather. (Courtesy of Chuck Peterson.)

This version of water skiing called riding the plank was a popular lake activity. The rider would obtain a board that measured approximately two feet by three feet. He would balance on the board, holding on to a rope that was attached to the motorboat. As the boat gained speed, the plank rider would skim across the surface of the water. (Courtesy of Chuck Peterson.)

One of the problems found in the early sailboats was their tendency to develop leaks. They frequently had to be hoisted out of the water, turned over, and have lead or graphite applied to the bottoms. This boat, *First Start*, finished last. It was troubled with leakage. Clarence Peterson finished first. (Courtesy of Chuck Peterson.)

The McHenry County Historical Society acknowledges the importance of historically important sites in the county by placing a plaque on those sites. In 1997, the historical society placed this plaque on the Pistakee Yacht Club. It was the 56th such site honored by the historical society. (Courtesy of Cheryl Twomey.)

Over the history of the yacht club, the position of commodore has traditionally been held by a male. In 1980, Caroline Nelsen broke that tradition by becoming the first female commodore. It was not until 2006 that a second female, Catherine Boetcher, served in that position. (Courtesy of Cheryl Twomey.)

Each year the membership of the Pistakee Yacht Club posed in front of the clubhouse for its official portrait. In 1942, membership was down because of World War II. Rationing of gasoline and food items also curtailed many of the club's social events. George Maypole, who became a state senator, served as commodore. (Courtesy of Chuck Peterson.)

Each year trophies earned during the sailing season are presented at the annual sailors' dinner. The majority of the trophies are perpetual trophies that are retained by the club and the winner's name is inscribed on it. Many have been donated by or in memory of club members. Cheryl Hartmann displays the awards for the 1981 award dinner. (Courtesy of Cheryl Twomey.)

In the early 1960s, the inauguration of a junior sailing school brought new members to the yacht club. Young sailors were taught how to handle a sailboat under the watchful eyes of seasoned instructors. Participating in a yacht school class are Kyle Twomey (front) and Ian Spadero. (Courtesy of Cheryl Twomey.)

YACHT RACE ON PISTAKEE LAKE. MC HENRY, ILL.

From the 1920s to the end of World War II, the six buoys to mark off the racecourse would be put in the water each spring and removed each fall. After that time the big balloon-type buoys were used and would be set up by the judges for each race. All races began and ended at the yacht club. (Courtesy of Patricia Schafer.)

The nonsailing activities at the yacht club were often fun-filled evenings. Many of them had a theme, such as this mock wedding with everyone impersonating Groucho Marx. Everyone wore fake noses and glasses. The men did not forget their bowties. (Courtesy of Patricia Schafer.)

This map of Pistakee Lake and the bay was first published by the yacht club in the 1938 club year book. The names and location of all the members' homes are shown on the map. The locations of the six buoys for races are also noted. (Courtesy of the Pistakee Yacht Club.)

While the yacht club was the social center of summer activities, it was also the place for winter fun. Once Pistakee Bay became solidly frozen, ice skates came out of storage and friends met down at the bay in front of the yacht club for an afternoon of ice-skating. Ice-skating parties replaced sailing parties. (Courtesy of Cheryl Twomey.)

Wintertime was not the end of sailing. Special iceboats were used once the lake was frozen. The sailors would raise their sails and wait for a nice stronger breeze to blow them across the bay. With large gusts of wind, speeds up to 100 miles per hour were reached. Just as there were sailboat races in the summer, winter enthusiasts enjoyed competing on the ice. (Courtesy of Chuck Peterson.)

Six

At Play
Pistakee Bay

A shallow lake with murky shores and tall grasses does not seem to be the sort of place that would become the center of a recreational area. As camps and resorts began to appear on the shores, families began to spend their summers here. The important politicians and wealthy businessmen from the city of Chicago also found their way to Pistakee where many built large, impressive homes.

In the late 1800s, the area was primarily a hunting and fishing paradise. Because of the water and tall grass, ducks were plentiful. Many fish populated the water, allowing excellent fishing. Pitzen's Point or Justen's Point were popular camping areas for the fishermen. One of these early visitors was Noah Pike, a businessman from Chenoa. He is considered to have built the first cottage on Pistakee Bay in 1884.

Stillings Hotel, the first hotel on the bay, attracted the wealthy. Built in the area known as the Pistakee cottage grounds in 1888, it was the most luxurious of all the hotels, complete with bowling alley, meat market, and grocery store. The well-groomed lawn with swings and hammocks encouraged lounging on the grounds. The proprietor, Ben Stilling, sponsored powerboat races. Other hotels, including the Oak Park Hotel, the S. J. Mellon Hotel, and the Mineral Springs Hotel, were also popular hotels on the bay. Family resorts such as Pitzen's and Pink Harrison's accommodated fishermen and families in smaller cottages.

Summer life on the bay was a continuous party. While water activities occupied everyone during the day, evenings were filled with parties and dancing. Bands both local and well-known appeared at the resorts or at the Pistakee Yacht Club. Music and laughter permeated the air late into the night.

Sailboat racing was not the only way Clarence Peterson enjoyed sailing on the bay. He could also be seen, as in this 1910 photograph, giving sailboat rides to bay visitors. His boat would hold up to 20 passengers. (Courtesy of Clarence Peterson.)

Members of the Peterson family and neighbors in their work clothes take a break and pose for this photograph taken in 1910. Families would come out to the bay on weekends and camp while building their summer homes. The lure of the bay would often pull them from their work. Francis O. Peterson is pictured standing second from left. (Courtesy of Chuck Peterson.)

This view from the shores of the Oak Park Hotel looks east toward Coon Island. Homes on Coon Island were reachable only by boat. On the left hand side the small Miller's Lighthouse that stood on the west shore of the island from the early 1900s can be seen. The lighthouse served as a landmark for many people boating in the lake over the years. Pictured at right is a closer view of the lighthouse taken in 1914. The lighthouse remained as a beacon on the lake until approximately 1940, when it just fell over into the lake. (Courtesy of Chuck Peterson.)

Half Moon Island was a small, crescent-shaped island located in Pistakee Lake. It was owned by the William Moore Miller family of Chicago. In 1898, the Miller family began building this small cottage on the island. The Miller family is shown gathered on the porch. The land was so low that during times of high water the cottage was completely surrounded by water. (Courtesy of Gail Carter.)

Building the large house on Half Moon Island in 1900 was a difficult task. All the materials had to be transported out to the island by boat. Charles Stephens works on the framing of the main house. Often inclement weather would interfere with the planned weekend of work. (Courtesy of Gail Carter.)

The gentleman in the center is the patriarch of the Miller family, William Moore Miller, who first purchased Half Moon Island. He is pictured with his family on the island. Miller was born in Ireland in 1832 and immigrated to Chicago where he became a successful businessman. (Courtesy of Gail Carter.)

The Miller/Rogers family would travel from Chicago each week to spend time on Half Moon Island. After arrival at the dock by livery boat, they pose for a photograph. Note the Half Moon Island flag on the left side of the dock. (Courtesy of Gail Carter.)

The influx of summer people to Pistakee Bay would begin around the third week in June, when the Chicago public schools went into summer recess. Families loaded with personal belongings and food would board the Chicago Milwaukee Railroad in Chicago and arrive in Fox Lake, leaving the train at the Pistakee station on the shores of Fox Lake. From here boat liveries, such as this one piloted by Mat Pitzen, would load passengers and their belongings and transport them to their homes on Pistakee Bay. The women and children would spend the summer at the lake. Husbands would make the trip out on Friday after completing their workweek in the city, often bringing additional food items for the family. On Sunday the men would return to Chicago. (Above, courtesy of Chuck Peterson; below, courtesy of Michael Clark.)

Summerhouses were built along the bay by many Chicago residents starting in the late 1800s. This house was the home of Joseph Peterson and was built sometime between 1898 and 1900. The house had a steeple that was visible from the bay. Over the years the house has been remodeled, but the steeple has been preserved. (Courtesy of Chuck Peterson.)

This well marked the Iron Spring located on Eagle Point at the rookery. It was a favorite gathering place for visitors to the point. Here a group of visitors gather around the well. Even when coming to the country, dress in the early 1900s was very formal. (Courtesy of Chuck Peterson.)

In the late 1800s, visitors to the bay area often camped in tents on the shore. Some of the visitors came to camp, fish, and hunt. Others would use tents while they were building their summer cottages. Conditions were primitive as there were no roads or electricity. (Courtesy of Patricia Schafer.)

Indoor plumbing was not available on Pistakee Bay in the early 1900s. An outdoor privy was often one of the first things constructed on the land. Often temporary outhouses such as this one were built with whatever scrap lumber was available. Later they would be replaced by sturdier structures. (Courtesy of Chris Kerwin.)

On a warm sunny day in the early 1900s, from left to right, Amelia Peterson, Ruth Schmidt, and Alma Olsen spend a day on the pier at the yacht club. It was usually the men who sailed while the wives enjoyed the outdoor air, sitting on the lawn or porch of the club. (Courtesy of Chuck Peterson.)

Formal posed photographs were popular in the early 1900s. This photograph was taken using a false background of an outdoor scene. Lynn Peterson is perched on the burro. Women's hats were popular and were seen in varied styles. Pictured from left to right are Russ Peterson, Lynn Peterson, and Ruth Schmidt. Paul Schmidt is seen leaning against the burro. (Courtesy of Chuck Peterson.)

This scene on Pistakee Bay in front of the Stillings Resort was taken in 1914. The sailboats line the docks while an excursion boat can be seen crossing the center. On the right a barge, a flat-bottomed boat, is pictured. Barges were often used during sailboat races as the judges' stand. They were the precursor of today's pontoon boats. (Courtesy of Chuck Peterson.)

These finely-dressed gentlemen, in their suits and top hats, take time to enjoy a glass of beer. Beer was a favorite drink among the German farmers and businessmen, just as it had been in Germany. At one time there were three private breweries in the basements of local houses. In the front row, from left to right, are Joe and Hank Hettermann and John Smith. (Courtesy of Harry and LuAnn Smith.)

Johnsburg once had a small airport. This airplane did not land there but rather on the water of Pistakee Bay, in front of the Oak Park Hotel. The plane was retrieved by Fred Smith. The passengers standing around the plane are dressed in heavy winter coats. Travel by small private plane often was cold because the plane was not heated. (Courtesy of Harry and LuAnn Smith.)

In winter, local residents still used the lake for ice-skating and ice fishing. But whenever the ice froze at least two inches thick, ice cutters such as this could be found on the frozen ice cutting large blocks of ice that would be placed in the icehouse and packed with straw. The ice would last through most of the summer to keep food cold. (Courtesy of Mary Jane Bartlow.)

James A. Pugh, a Chicago millionaire, was born in 1864. A summer resident of Coon Island, Pugh was active in boating and a member of the yacht club. In addition to sailboats, Pugh was known to pilot a fast motorboat known as the *Disturber*. The *Disturber* could travel at speeds up to 35 miles per hour. (Courtesy of Michael Clark.)

This photograph was taken in 1924 as a group of men transported an automobile across the lake. The barge containing the automobile is being pulled by one of the Pitzen boats. The automobile may be moving to the other side of the bay by barge because adequate roads were not available. (Courtesy of Mary Jane Bartlow.)

In the 1950s, the Hartmann family opened Sports Unlimited, a hunting club. Bud Hartmann gives a visiting reporter a first-hand hunting experience. Dressed in their hunting shirts, hats, and boots, they explore the perils of climbing over the fence while balancing their hunting rifles. (Courtesy of Cheryl Twomey)

Ethel Hartmann was one of the few women of the time who enjoyed hunting. In this 1958 photograph, she is shown displaying some of the Chukar partridge that she has hunted. The partridge were one of the most popular birds for hunters. (Courtesy of Cheryl Twomey.)

Sailing was one of the favorite activities for those who summered on the bay. The stronger the wind, the more exciting the ride as the boat picked up speed. From left to right, Frank Waters, Jean Ericsson, and an unidentified companion enjoy an afternoon on the water. (Courtesy of Carol Janssen.)

Sailing can be an exhilarating experience, provided that the boat can be maintained upright. Bob O'Connor (left) and Jean Ericsson were not fortunate enough to maintain that position on this trip. In this 1938 photograph, O'Connor holds the backstay to try to pull the mast out of the water. (Courtesy of Carol Janssen)

The year 1960 was a year of high water, as seen in this photograph of Pitzen's Camp. Water covered the beach and in some cases flooded the cabins and shop along the shore. Even the gas pump that sold gasoline to be used in the boats stands completely surrounded by water. (Courtesy of Mary Jane Bartlow.)

The flooding extended back and over Pitzen Road, making it impossible for residents to enter or leave their properties by automobile. Because their cars were inoperable in the high water, Pitzen's orange-colored rowboats were often borrowed to allow movement. Neighbors would assist each other in times like this. (Courtesy of Mary Jane Bartlow.)

In 1888, Ben Stilling opened Stilling's Resort. It is considered to be the first hotel built here. The Stilling was an elegant place and attracted many politicians and wealthy businessmen from Chicago. For an easy relaxing day, visitors could lounge in the hammocks on the lawn. For more activity, rowboats, bowling, or a visit to the dance hall were available. A grocery store and butcher shop were also on the grounds. (Courtesy of Patricia Schafer.)

This resort owned by Sven J. Mellin opened in 1902 and was originally called the Pistakee Point Club. It was located on Bald Knob, giving it excellent views of the bay. Among the amenities offered were a bowling alley, boats to rent, and a bar. Mellin, like some other local resort owners, was known to have violated Prohibition laws, which resulted in fines and temporary closures. (Courtesy of Michael Clark.)

Joseph Mertes opened the Oak Park Hotel in summer of 1895. He started with 15 bedrooms on the second floor. On the first floor, the dining room would seat about 30 guests. The kitchen originally contained a wood stove. The bedrooms were lit by kerosene lamps. A bed, small washstand, and a chair completed the room. Rates were $4 a day. The charge was $1 for the room and $1 for each meal. (Courtesy of Michael Clark.)

The original bar was housed in the basement. Later a separate building was built (pictured on the left) to house the bar, bowling alley, and dance hall. A grocery store opened in the vacated space. During Prohibition, the bar retreated back to the basement of the resort where, according to Elsie Mertes, Joseph's daughter, beer was readily available. (Courtesy of Patricia Schafer.)

The dining room of the Oak Park Hotel was well known for excellent food. Dinners of fresh lobster tail, double lamb chops, or filet mignon were available for $1.25 in the early 1900s. Fresh fried pan fish when in season was only 85¢. The dining room pictured here in 1912 is festively decorated. The furniture for the resort was made by Jacob Justen of McHenry, with an agreement that it would be paid for in the third year of the hotel's operation. (Courtesy of Tom Fuchs.)

Entertainment brought in visitors. Joseph Mertes provided unique activities at the hotel. Until 1901, a wild game dinner was held each fall. In addition to Saturday night dances, Mertes would sponsor speedboat races on the bay. In winter after the bay had frozen, horse races would be held in front of the hotel. In 1934, after Prohibition had been repealed, an unsuccessful attempt at bombing the hotel occurred. (Courtesy of Michael Clark.)

The original Pink Harrison Resort was built on the top of the hill. Christine Harrison encouraged her husband, Frank, known as "Pink," to open the resort during the Depression years. The small building on the left was the first bar. The larger building held the resort's kitchen in the basement. Food was then carried up to the dining room on the first floor. The resort was known as the playground of Pistakee. (Courtesy of the Harrison family.)

These small fishing cabins were part of Pink Harrison's resort. The original cottages contained a small kitchenette and sleeping area. Bathrooms and showers were located at the main house up on the hill. Later larger cabins with full amenities were added. The cottages remained popular until the 1980s. (Courtesy of the Harrison family.)

While the 18th Amendment was not repealed until December 1933, in April of that same year, a bill was passed allowing the sale of beer. Posters such as this were posted in restaurants and bars. This one hung on the wall of Pink Harrison's bar from 1933 until the resort and bar closed in the 1980s. (Courtesy of the Harrison family.)

This bar was the site of many summer festivities. Tom "Pinkie" Harrison is pictured tending bar. The Harrison resort rented boats, which were mostly used by fishermen. The 75 boats would all be rented and out on the bay by 7:30 in the morning. They would return by 9:00 and then be rented again. (Courtesy of the Harrison family.)

Pink Harrison's Log Cabin Inn was located right at the water's edge. A building located on the hill was moved down to the waterfront. Warm summer evenings would find guests of the resort sitting on the porch with beverages in hand waiting for their table. Marilyn Harrison handled the cooking duties from the late 1950s. Radio personalities, such as Fibber McGee and Molly, were known to spend time at this resort. (Courtesy of the Harrison family.)

Rowing a boat was not the only way to travel across the bay. This unique flat-bottomed boat was propelled by standing and using a pole to push the boat along, similar to the way a gondola is moved. The small child seems to be enjoying the ride. In the early 1900s, life jackets were not required on small children as they would be today. (Courtesy of Mary Jane Bartlow.)

The Pitzen family settled in this area along the bay in 1843. It became known as Pitzen's Point. The farm was located on top of the hill, where it commanded a fine view of the bay. This aerial view of the farm was taken in 1900. (Courtesy of Mary Jane Bartlow.)

Beautiful flower gardens such as this could be found throughout the Pitzen property. They were the work of Lewis's mother, Margaret. The large birdhouse attracted many birds to the area. A birdbath can be seen on the left. (Courtesy of Mary Jane Bartlow.)

In 1918, young Lewis Pitzen, who was 18 years old, opened a fishing camp on the shore. He rented boats and sold bait and beer. A barn stood on the property, and fishermen were allowed to sleep up in the rafters. The popularity of the area for fishing and hunting made the business profitable. He opened a tavern and began to build cabins to be rented, not only to fishermen alone but to families who came to spend some time in the country, enjoying the lake's activities and the fresh air. Pictured below is the original bar and cabins one and two on the premises. The original cabins contained bedrooms, a small kitchen area, and a sitting room. A communal outhouse was shared by the families. (Courtesy of Mary Jane Bartlow.)

In the early 1900s, the Pitzen boats were easily recognizable by their bright orange color. The early boats were made of wood and had to be kept in the water to keep from drying out. If left out, the wood would contract and the boats would leak. Some of the boats, as seen in this photograph, would be anchored off shore. When they were rented, Lewis would take a boat out to the anchored boat, raise the anchor, and tow it back to shore. In later years, the boats were aluminum, requiring less care. The Pitzens had 50 orange boats. (Courtesy of Mary Jane Bartlow.)

Lewis Pitzen stands flanked by his fishing buddies Herb Kranz (left) and Roy Olsen (right) while they display their fish. Various varieties of fish were caught in the bay, many of them very large, as seen here. Lewis's dog Spike is also pictured. Lewis had a series of dogs each named either Spike or Spotty. (Courtesy of Mary Jane Bartlow.)

Summertime brought playmates for the Pitzen children as guests old and new arrived at the resort. The wire basket in the water was the bait basket, which held live bait that could be purchased by the fishermen. An unattended fishing pole rests at the edge of the pier. (Courtesy of Mary Jane Bartlow.)

Known as the Rose Villa, this mansion was the home of George Sayer and his wife, Rose. Sayer, a Chicago businessman who owned a chemical company and a butcher supply business, was considered the wealthiest resident of the bay. This house was built in 1910 using artificial stone from McHenry. It is said to have had 32 rooms, eight fireplaces, and eight bathrooms. There was space for a ballroom on the third floor. After Sayer's death in 1926, the house was sold to William (Billy) Skidmore, a known gambler with ties to organized crime. He removed the two wings from the house and used the stone to build a coach house. (Courtesy of Walter Gehlaar.)

To the south of the entrance was the dining room. A large room, it could accommodate dinner parties with many guests. The fireplace provided a warm glow to the room. The French doors opened onto the patio, overlooking the bay. (Courtesy of Walter Gehlaar.)

This divided stairway provided an attractive entrance to the mansion. A separate service stairway was located in the rear of the house. Walter Gehlaar poses in front of the stairway sipping an afternoon refreshment. The Gehlaar family owned and lived in the mansion from 1962 to 1978. (Courtesy of Walter Gehlaar.)

This large bedroom was one of several guest rooms in the Sayer mansion. The walls were made of plaster and then covered with canvas and hand painted. The French doors lead out to a private deck with a grand view. (Courtesy of Walter Gehlaar.)

In addition to his home on the bay, George Sayer owned five farms in the area. He also began acquiring many exotic species of birds and deer, which were kept on his property and referred to as Deer Park. Many of the animals were shipped from around the world and transported to the area on the Chicago and Northwestern train to McHenry. (Courtesy of Michael Clark.)

The Sayer property stretched along the lakefront. On the left is the Sayer mansion with the American flag flying. On the right, some of the Sayer farms and barns can be seen. Sayer had a large orchard of fruit trees, and many ornamental shrubs could be found on his property. (Courtesy of Patricia Schafer.)

Known as the father of Pistakee Bay, Noah H. Pike was believed to have built the first cottage on the bay. Pike was a wealthy lumber builder from Chenoa who came to the bay in the late 1800s to fish and hunt. Pike built several cottages, some of which he rented to other summer visitors. Pike and his wife, Helen, helped raise their nieces Helen and Ruth Shelton when their mother died at an early age. Pike and his brothers were all veterans of the Civil War, and three of them had been imprisoned during the war in the same facility. Noah's brother Ivory of Oak Park had a house in the Rocky Beach subdivision on the bay. (Courtesy of Sally Lucke Elkes.)

This is one of the first houses built by Noah Pike. This house was made of lumber and served as a Pike summer home for many years. It was eventually moved to the back of the property and replaced by a larger house. (Courtesy of Sally Lucke Elkes.)

E. R. Busch built this house in the area known as Palm Beach, next to the Ericsson house. Busch was a member of the family from St. Louis that owned Anheuser Busch Brewing Company. Busch was a member of the yacht club. (Courtesy of Michael Clark.)

Henry Ericsson, a prominent architect and builder from Chicago, first came to the bay area because of ill health. He spent his time at the Stilling's hotel, where his health improved and he fell in love with the area. Ericsson built the Mineral Springs Hotel around 1892 on Pistakee Bay's south shore. The hotel attracted many of Ericsson's prominent city friends. Ericsson is pictured here on the porch of his summer home. (Courtesy of Carol Janssen.)

The Mineral Springs Hotel was built by Henry Ericsson to accommodate his many visitors. The area contained many small springs such as this one shown on the lakefront. This area of the bay was not very deep, and a boardwalk was built connecting the hotel with the sandy beaches of Sandy Hook. The hook, on Palm Beach, is where Ericsson built his cottage. Visitors from the hotel would walk across the boardwalk to sun and swim. (Courtesy of Michael Clark.)

The Mineral Springs Hotel was sold by Ericsson in the early 1900s to A. H. Kingsley. Kingsley ran the hotel for several years. In 1913, it was sold to George Fritz, who reverted to the name Mineral Springs Hotel. This area of the lake was known for the prevalence of clams, and the Kingsley often held clambakes that were well attended. (Courtesy of Michael Clark.)

Around 1920 the hotel was sold to Henry Saal, president of the Perkins Phonograph Company, for use as a private company resort. The hotel burned in the late 1920s. Saal rebuilt it as a private house. After Saal's death, the building had many owners and was used as a military academy and a children's home and finally was purchased by the Italian Welfare League. (Courtesy of Michael Clark.)

The Italian Welfare League was an organization that opened a children's camp for Italian American children. The camp was a legitimate organization and provided summer country experience for many city children. The Giancana family was a major fund-raiser for the camp. Here a group of children are seen enjoying the pool. (Courtesy of Michael Clark.)

Min-Vra, the summer home of Henry Ericsson, was built in the area known as Palm Beach because of its sandy beaches.. Originally the house was being built for James Pugh, but Pugh's financial reverses after the foundation was poured caused him to abandon the project. Ericcson, who developed the Palm Beach area, completed the house for his own use. (Courtesy of Pat Schafer.)

The green stone fireplace in the living room of Min-Vra is older than the house itself. John Root, a partner of Louis Sullivan, designed it in the late 1800s for the Michigan Avenue mansion in Chicago of George Hankins. Ericsson was demolishing the mansion and had the fireplace dismantled and each brick numbered so that it could be rebuilt at Pistakee. (Courtesy of Peter and Jill Theis.)

Henry and Lena Ericsson with their seven children, pose for a family portrait in 1915 on the occasion of their daughter Florence's wedding. Pictured are, from left to right, (first row) Virginia, Henry, Lena, and Dewey Ericsson; (second row) Martha, Clarence, Florence, Walter, and Hazel Ericsson. (Courtesy of Carol Janssen.)

This small cottage was built around 1934 for use as a children's playhouse. Clarence Ericsson, son of Henry, also went into the architectural and building field. In the 1930s, business was not thriving so Clarence put his time to use building this playhouse. (Courtesy of Carol Janssen.)

This sitting room was the main room in the cottage. The high ceiling allowed the hanging of the large iron chandelier. The fireplace is faced with local stone. Note the child-sized furniture in the room. (Courtesy of Carol Janssen.)

This area of Palm Beach, where Henry Ericsson built his summer home, was a wet area that was drained and raised before it could be built upon. The addition of the McHenry Dam on the Fox River caused an increase in the depth of the lake and increased the flooding of the area. Bill, Caryl, and Dorothy Ericsson walk through the flooded yard. (Courtesy of Carol Janssen.)

Cross-country skiing was a good way to enjoy the snow around the bay. Jean Ericsson stands holding her skis, which tower above her. The skis used in 1930 were wide wooden planks, much wider and longer than those used today. The bindings used to hold the skis in place were mere straps with buckles. It was difficult to keep the skis in place. (Courtesy of Carol Janssen.)

Nelson-La Moon Villa, Pistakee Lake, Fox Lake, Ill.

Barney Nelson and Ayel LeMoon were business partners from Chicago who owned a trucking company. They built identical, adjacent houses along the bay and had them furnished also identically. Ericsson's son Walter married Alice LeMoon, daughter of Ayel LeMoon. (Courtesy of Pat Schafer.)

This cottage was built on Eagle Point in 1924. Because the land was low and subject to flooding, it was built on stilts. It was the home of Lulu and Henry Wolff. The Wolff family was among the earliest settlers on the point. (Courtesy of Chris Kerwin.)

113

The McAnsh-Haas-Edelman Residences, Pistakee, Ill. 80608-r

Andrew McAnsh was a furniture dealer and involved in other business activities. He summered on Pistakee Bay. His home was named Lochraine, as was his motorboat. His sailboat had the distinct name of *Butinski*. McAnsh was considered an eccentric character and is believed to have been visited by mobsters and by movie stars. He was also involved in the development of Sarasota, Florida. His neighbor Joseph Haas was a well-known Pistakee resident. Active in the yacht club, Haas served as commodore and promoted powerboat races. He developed a stock farm behind his home, a farm that he subsequently sold to Henry Tonyan. A self-made businessman, Haas entered politics in 1884 as a school board member. He rose through the ranks, serving on the Chicago City Council and as state senator and county clerk and recorder. (Courtesy of Michael Clark.)

This house was built in the late 1800s but has had additions over the years. It was originally built by an executive of the Cracker Jack Company named McCabe. The large front porch that overlooks the lake has been enclosed. (Courtesy of Chris Kerwin.)

Bill Decker displays the northern pike he caught on October 15, 1950, at the Wolffs' estate on Eagle Point. The fish weighed 11.5 pounds and was measured at 37 inches long. (Courtesy of Chris Kerwin.)

William Lorimer purchased his property from his neighbor to the north, Henry L. Hertz. Lorimer, who was a resident of Garfield Park in Chicago, was known as the "Blond Boss" and had political control of the city, except for the northwest side. It was controlled by Hertz. He was considered a maker of county officials, mayors, and even governors. "Big Bill" Thompson, three-time mayor of Chicago, was one of Lorimer's protégées. Lorimer built a large house on the bay. It was large enough to accommodate his 13 children who summered there. In 1910, Lorimer was elected to the United States Senate. The *Chicago Tribune* spent two years investigating Lorimer on a charge of buying votes. He was removed from the senate because of these allegations. (Courtesy of Michael Clark.)

William Pugh was the president of the Pugh Terminal Warehouse. The warehouse was built by Henry Ericsson. Pugh lived on Coon Island and liked racing fast boats. He was active in the Pistakee Yacht Club and served as commodore in 1910 and 1911. His favorite boats were named the *Disturber*. They had a powerful Dusenburg motor, which is said to be capable of going 60 miles per hour. (Courtesy of Michael Clark.)

Sometime shortly after 1916, Lorimore sold the house to Charles Hollenbach. Hollenbach was the owner of a sausage company. He purchased the main house and also the Hertz property. The Hertz house was moved back on the property to make way for another house. The Hertz house was later demolished. This photograph of the Lorimore-Hollenbach house is from the late 1800s. (Courtesy of Dawn and Mark Wicks.)

The Hollenbach property had a separate building to house the bar and bowling alley. The bar was a large ornate wooden structure that was brought from Chicago. The Hollenbach staff poses in front of the bar. Often parties that began at the yacht club would end here. After the band finished at the yacht club, it would pack up its instruments and move to this bar. (Courtesy of Charles Gies.)

Fancy automobiles caused as much attention in the early 1900s as they do today. This coupe convertible was unique looking and caused heads to turn as it drove down the street. The rumble seat, a feature no longer seen in automobiles, allowed it to carry four passengers instead of just two. (Courtesy of Chuck Gies.)

Wintertime meant putting the boats away and bringing out the toboggan slide. Starting at the top of the hill, the sled would slide down the hill, picking up speed as it went. With eight people on the sled, it would be a fast ride. (Courtesy of Charles Gies.)

This brick house belonged to James Mraz and his wife, Bessie. The brown brick house shown here in 1911 was Mraz's second house on the bay. The first Mraz house was on the opposite side of the bay. (Courtesy of Dawn and Mark Wicks.)

Swimming or bathing, as it was called in the early 1900s, is the day's activity for this group. The lake prior to the placement of the dam was not very deep, allowing the swimmers to stand in the water and making it a safe area for the children to swim. (Courtesy of Dawn and Mark Wicks.)

For most residents on the bay, a boat is a necessity. The Hollenbach family was no exception. The family boat is a long sleek craft able to achieve high speeds. The Hollenbachs, like their neighbors, were active members of the yacht club. (Courtesy of Dawn and Mark Wicks.)

The house on the right is known as the Pink House because of its pink exterior. The house is reminiscent of a California home, and it actually is a duplicate of one that was built in California. The house was purchased by James Mraz. (Courtesy of Dawn and Mark Wicks.)

Adams Corner was a popular camping ground located near the Oak Park Hotel. It was a place for summer visitors to shop for groceries and to purchase gasoline for their automobiles. The candy store was a favorite of the local and visiting children. (Courtesy of Michael Clark.)

Half Moon Island was also known as Duck Island because of the large number of ducks that migrated there each year. Today Half Moon Island is mostly submerged and not habitable due to a higher water level than was present in the early 1900s. (Courtesy of Michael Clark.)

The Stillings Hotel was out of business as a hotel around 1920. The Chicago Archdiocese became owners of the property. Catholic charities began a camp for children from Chicago and the suburbs that was available on a sliding scale fee. This grotto was present on the grounds. (Courtesy of Patricia Schafer.)

Eagle Point Rest, Pistakee Lake, Fox Lake, Ill.

The Eagle Point Restaurant was present at this location in 1917, when this photograph was taken. The restaurant underwent several changes over the years and was also known as Clemens Restaurant. In the 1950s and 1960s, it was known as the Puppet Bar because of the many musical toys present. (Courtesy of Patricia Schafer.)

A cottage at the lake is not all fun. Just like any other property, there is work to be done. A group of volunteers gather at the yacht club to pull the piers out of the water for the winter. In the spring they will return to put the piers back into the water. (Courtesy of Chris Kerwin.)

Summer cottages at Eagle Point were built in 1922. Built close together, they were all built on stilts because of the possibility of flooding. Still it did not stop visitors from spending their summers at the lake. (Courtesy of Chris Kerwin.)

Coon Island was a favorite summer destination for many families. The Miller family, known for their lighthouse, had a summer cottage on the island. Careful planning was needed to be certain enough food and supplies were brought to the island. (Courtesy of Michael Clark.)

A. J. Smith pilots the *Frances S*, an excursion boat, through the lakes. A local candy store and ice-cream shop was a popular place on the hot summer days. Excursion boats were popular means of transportation to the bay. (Courtesy of Chuck Peterson.)

Automobiles were not common in large numbers around the bay. Roads were not plentiful. Many were dirt trails often with tree stumps in them. Driving an automobile was a difficult job, trying to avoid the stumps so as not to blow the tires. (Courtesy of Chuck Peterson.)

Although today there are more motor-driven boats present on the bay than there were 100 years ago, the sight of the white sails can still be seen. The weekend regattas and other races held by the yacht club continue to bring sailboats into the bay. The beauty of the white sail against the blue sky and the glistening of the water as the sun shines down is a sight more beautiful than any motor-driven vehicle can ever be. (Courtesy of Chuck Peterson.)

Bibliography

Andreas, Duane D. *What We Remember Before We Forget*. Ringwood, IL: Self-published, 2006.
Barth, Nicolle, Sharon Barth, and Nancy Fike et al. *McHenry County in the Twentieth Century*. McHenry, IL: McHenry County Historical Society and Heart Publications Publishers, 1994.
Clark, Michael and Sharon Pump. *Historically Yours*. Fox Lake, IL: Michael Clark, 1991.
Ericsson, Henry. *Sixty Years A Builder, The Autobiography of Henry Ericsson*. Chicago, IL: A Kroch and Son Publishers, 1942.
Short, R. and Jerry Klien et al. *Johnsburg Community Club 65th Anniversary*. Johnsburg, IL: Johnsburg Community Club, 1987.
Nye, Lowell Albert, ed. *McHenry County Illinois 1832-1968*. Woodstock, IL: McHenry County Board of Supervisors Publishers, 1968.
Peterson, Chuck, ed. *Pistakee Yacht Club–100 Year Celebration 1897-1997*. Lincolnwood, IL: Irving-Cloud Publishing Company: 1997.
Parish Council, ed. *St. John the Baptist Church's Diamond Jubilee*. Johnsburg, IL: Self-published, 1975.

ACROSS AMERICA, PEOPLE ARE DISCOVERING
SOMETHING WONDERFUL. *THEIR HERITAGE.*

Arcadia Publishing is the leading local history publisher in the United States. With more than 3,000 titles in print and hundreds of new titles released every year, Arcadia has extensive specialized experience chronicling the history of communities and celebrating America's hidden stories, bringing to life the people, places, and events from the past. To discover the history of other communities across the nation, please visit:

www.arcadiapublishing.com

Customized search tools allow you to find regional history books about the town where you grew up, the cities where your friends and family live, the town where your parents met, or even that retirement spot you've been dreaming about.